The Faraway Nearby

John Murrell is one of Canada's most frequently produced playwrights. *The Faraway Nearby* is his fourth study of an artist, following *October*, *Democracy*, and *Memoir*, a portrait of Sarah Bernhardt which has been translated into fifteen languages and performed in over thirty-five countries. As well as being recognized as an award-winning playwright, John Murrell is a translator of numerous classics into English, including several of Chekhov's plays, and most recently, a new prose translation of *Cyrano de Bergerac*.

The Faraway Nearby

by John Murrell

Blizzard Publishing • Winnipeg

The Faraway Nearby first published 1996 by
Blizzard Publishing Inc.
73 Furby Street, Winnipeg, Canada R3C 2A2
© 1995 John Murrell

Cover art by Diana Thorneycroft (photo by Larry Glawson).
Printed in Canada by Friesen's Printing Ltd.

Published with the assistance of
the Canada Council and the Manitoba Arts Council.

Caution

This play is fully protected under the copyright laws of Canada and all other countries of the Copyright Union and is subject to royalty. Except in the case of brief passages quoted in a review of this book, no part of this publication (including cover design) may be reproduced or transmitted in any form, by any means, electronic or mechanical, including recording and information storage and retrieval systems, without permission in writing from the publisher, or, in the case of photocopying or other reprographic copying, without a licence from Canadian Reprography Collective (CANCOPY).

Rights to produce, in whole or part, by any group, amateur or professional, are retained by the author. Address perfomance rights inquiries to John Murrell, 129 10th Avenue N.E., Calgary, Canada T2E 0W8, or to The Susan F. Schulman Literary Agency, 454 West 44th Street, New York, USA 10036–5205.

Canadian Cataloguing in Publication Data

Murrell, John, 1945–
 The faraway nearby
 A play.
 ISBN 0-921368-56-9
 1. O'Keeffe, Georgia, 1887–1986 — Drama. I. Title.
PS8576.U695F3 1995 C812'.54 C95-920181-5
PR9199.3.S44F3 1995

This play is for Gladys McLean, teacher.

The Faraway Nearby was first produced at Perseverance Theatre (Molly Smith, Artistic Director) in Juneau, Alaska, in April 1994, directed by Joanna McIntyre, with Luan Schooler as Georgia O'Keeffe, Jake Waid as Juan Hamilton, and Lucy Peckham as The Musician. Set and Lighting Design were by Arthur Rotch, Costume Design by Vikki Benner, Sound Design by Lucy Peckham, and the Stage Manager was Susan Wilder.

The Faraway Nearby was next produced by Belfry Theatre (Glynis Leyshon, Artistic Director) in Victoria, British Columbia (January 1995) and by Tarragon Theatre (Urjo Kareda, Artistic Director) in Toronto, Ontario (February–March 1995), in a production also directed by Joanna McIntyre. It starred Nancy Beatty as Georgia O'Keeffe, Richard Clarkin as Juan Hamilton, and Reid Robins as The Musician. Set and Costume Design were by Pam Johnson, Lighting Design by Bonnie Beecher, Music and Sound by Reid Robins. The Stage Manager in Victoria was Dorothy Rogers; and in Toronto, Beatrice Campbell.

Characters

GEORGIA O'KEEFFE
An artist, in her final years (her sixties through her nineties)
JUAN HAMILTON
An artist, in his early years (his twenties and thirties)

Setting

The setting for the play represents two of O'Keeffe's most significant "spirit centers" in northern New Mexico: her adobe home with its interior and exterior spaces of sparsely organized primitiveness; and the even more primitive, forbidding canyon and hills, one hundred miles west of her home, which she called "The Black Place".

The bare surfaces, pieces of fabric, bits of animal skeletons and seashells, and the few man-made objects of her home actually represent both or either of her accommodations simultaneously—one in the village of Abiquiu and the other, twenty-five miles north, at Ghost Ranch. O'Keeffe was attracted by the similarity between these spaces. She was attracted by their thick sloping adobe walls, their dark rectangular doors and windows, the intense solitude within their barbed-wire and stone and adobe fences, and we should be too.

There is also a striking similarity between the naked surfaces, both forbidding and inviting, of O'Keeffe's home(s) and those of The Black Place—so that "home" can be swiftly, simply transformed into "canyon" (through light, scrim, revolving platforms, or whatever)— or so that home seamlessly adjoins or "shades into" canyon.

Anything beautiful, simple, strong and close, as in O'Keeffe's lifework, is to be encouraged and explored. Any touch of high-tech gimmickry is foreign to the spirit of the play.

Part One:
Alone (1948–1973)

(Although the intensity, the color, etc. of light will change throughout this Part, the stage must be continuously lit. There are no blackouts as such between scenes.)

Scene One:
Afternoon at Home

(GEORGIA O'KEEFFE is sitting almost exactly as in the 1948 photograph by Philipe Halsman, on a low stone step, both legs stretched out to her left, her right arm draped proprietarily over the nose of a huge cow skull on the step in front of her.

She might be any age from fifty to ninety. Her skin is like taut, wrinkled, hand-softened leather. She wears no rings or jewelry. She wears a black flat-brimmed Western hat; its leather chin-tie dangles around her neck. Underneath the hat, a white scarf is tied flat across her brow, knotted in back, with its long ends pulled forward over her right shoulder. The broad collar of her white silk blouse is turned up, and its fluted cuffs are turned back over the sleeves of her tailored black jacket. She wears a black skirt, white or ivory stockings, and comfortable, beautifully scuffed leather shoes.

Much sagebrush [it would be good if we could smell it], the walls of her adobe home, and her adobe-like hills, are around and behind her.)

GEORGIA: Take the damned thing. Take it quick. I don't know why I ever said "Yes" to you in the first place, but I did say "Yes", so do the merciful thing at least and snap it quick. My left leg is going to sleep.—I want it strange, I want it stiff and formal, like a corpse buried sitting up, the way the cliff dwellers did it. They knew a

thing or two, the cliff dwellers. Whatever you do, don't try to make me look "life-like". This isn't life, it's a photograph. A photograph is nothing more than a tool to pry memory open, a clumsy tool. If we had better memories, we wouldn't need photographs at all.—Take the damned thing.—I know what you're thinking: once in a while, a photograph turns out to be art. Maybe. In certain hands. But that is not because it's "life-like". That is not life either, that is art. Art is one part life and nine parts the other thing. Art is the thing beyond, behind, beneath, inside. Even what you mean when you say "life" is only a surface, a thin skin, a handy package of flesh which is used to contain and protect the insides. It's when those insides come out and parade in the changing light, unashamed to be caught out of their skins—then you have something like art.—My right leg has gone to sleep now too. Please take the goddamned thing.—Do you seriously believe your photograph is any way to preserve or reveal a human being? *(She laughs.)* You are like all these people who think, "If I only knew more about her, about her education, about her family, then I'd understand her painting better. If only I had a few more details of her diet, her favorite tunes, her dogs, her love life, her bathroom fixtures—" Stupid people.

(There is the amplified sound of a camera shutter in operation and maybe a soft flash of light.)

Thanks. Wasn't that fun. Wasn't that important.

(She stands, shakes and stamps first her left foot, then her right, as she watches the photographer pack up, move away, and disappear. Then she lifts the cow skull carefully and carries it into her house. She sets the skull down on the sill of a large window, then moves to a sturdy radio/hi-fi console and starts a favorite record: the Sarabande from Bach's Suite No. 2 in D Minor for unaccompanied cello, performed by Pablo Casals. She returns to the window and looks out, one hand caressing the cow skull.)

Alone. Maria, gone for the weekend. And I finally said to my visitors, "Friends, you have worn out your welcome." They're gone at last, and I can't even remember who they were. And the boys who are patching the fence won't be back till Wednesday at the earliest. And my dogs wore themselves out on our run through The Faraway this morning. They'll sleep till feeding time. Everybody, everything gone, and I am thankful. Alone. And the light.

The nameless red of those timeless hills. And the right music, thank you, thank you, exactly the right voice to sing this place, this time of day: Casals, with his rough old Spanish hands, giving Sebastian Bach one hell of a rub-down ... And red, that red, this red. You, Red, although I have tried for a quarter of a century now, I have never gotten you right, have I? But I will. You're tricky, you're fast. You only stay for a moment, this time of year, this exact time of day. And only here. You aren't visible in the city, in the East, on the Atlantic or the Pacific, up north or south of the border. Just here. Yes, you are out there, Red, I know it. Even if I have to feel you, more than really see you, nowadays. I will track you down yet, seize and hold you for questioning. I will get you right. I can live until then.

(She leans back from the window, glances down at the cow skull, gives it a final caress, then moves into another room and starts to undress, down to her slip or other underwear. As she does this, the densely colored light outside her house changes from late afternoon to early evening, and the Bach Sarabande concludes.)

My old man ... *(She laughs.)* Yes, I called him that, even before we got hitched—and the more he objected to it, the more I called him that: "my old man" ... He took one of me which is a fairly good likeness. Up at Lake George, it was still spring, it was still cold. I can tell that by the look on my breasts. They are cold. Which is exactly what my old man wanted. "Shock," he said, something about "the look of surprise on those breasts as the cold air finds them." My face isn't even in the picture. Maybe that's why it's such a good likeness, why it deserves to be called art. Just my breasts and my hands. A bit of neck, a bit of belly. Like this: my hands arriving suddenly in the photograph like worried birds, to shelter the breasts ... my breasts. Yes, you pinned down more of the true me than anybody else, Old Man. Old Snake—you knew all my tricks: just let me grin or frown or smirk for the camera, and I can fool all the people all the time. It's a gimmick, it's a sideshow, it's a post card from the museum gift shop. But you—insisted on taking my hands alone, by surprise, my throat, my hips. And— "This is the best time," I said, "always, after you have been taking pictures of the rest of me, ignoring my face, this is always the best time between us, when you put down the camera, and you pull me into you again, and you are the camera now, you are the lens which

finds me and never even glances at my face, just ranges over the rest of me, and please don't think I am criticizing, I am so glad you don't want my face like you want the rest of me, because the human face is always more mask than meaning, even when a great artist gets his fingers behind the mask—his lips and his tongue between the mask and the face ..." Not long after that, after I said that to you in so many words, you stopped taking pictures of the rest of me—and then, even of my face. And our time together continued good—a damned sight better than most people ever know—but it was never again, after I spoke the truth about it, so good—*that* good.

(She pours a bowl of fresh water, then sits in a simple chair to wash her face, arms, hands and feet with a sponge or a soft cloth.)

I saw a boy out here, a while back, looked a lot like my old man. Like my old man must've looked before I ever met him. With the same huge floppy ears. Oh. *(She laughs.)* Once upon a time, I called you "Dumbo". *(She laughs.)* You didn't even know who that is. "It's Disney, Old Man, it's Walt Disney!" *(She makes a gesture of huge floppy ears.)* Nearly eighty at the time—you just stared at me and shook your head—like this. And I couldn't help myself—*(She laughs.)* God Almighty, I do not want that to find its way into some stupid biography: "She called the great Alfred Stieglitz 'Dumbo', and then laughed at him because he had never heard of 'Dumbo', laughed till she wet herself."—I saw a boy, a while back, doing odd jobs for Jim Hall around the Ranch. He had your ears. And mouth, and eyes. He didn't know anybody was looking at him, but I did the full catalogue: mouth, eyes, right ear and right profile, left ear and left profile, left shoulder and left flank seen from behind, right haunch and leg front view. I am not famous for my life studies, but if I admitted folks to the gallery behind these old eyes—to the portraits of men displayed down the corridors of my old nervous system ... They all think I'm three-quarters blind nowadays. I am three-quarters blind nowadays. But there are still some things I have no trouble seeing: that Red out there, that young boy like my old man.

(She finishes washing, then finishes undressing, and puts on a long expensive white nightgown.)

Alone. Bedtime, alone. I will not be coy or smug about having managed it for most of my long life, but I am so glad to be. From now on. Alone. I am glad. I am proud.

(She moves further into the darkness, toward her bed, which may or may not be seen.)

Scene Two:
Night at Home

(Sounds of the desert at night; then, as the light outside Georgia's house changes to full moonlight, the tall emerald-green jimson weeds in her patio burst into large, fleshy white, emerald- or violet-throated, trumpet-shaped, tendriled blossoms, many of them.

GEORGIA gets out of bed [we may or may not see her do so], moves into the room with the large window, and looks out at the jimson weed blossoms. Then she comes outside onto the patio, in her nightgown and bare feet.)

GEORGIA: So quiet in my house alone at night I can hear the moon slip out of the blue shirt pocket of the sky, to make the jimson weeds bloom. *(She goes to the many large white blossoms, touches them gingerly.)* You keep coming back. I pull you up, I chop you down, I leave you to dry in the sun, I burn the remains. But the seed is stronger and smarter than I am. You find some corner of an old wall or some rock to sprout up under. *(She smells her hands.)* So quiet I can hear the sound of your perfume inside, alone, even with my window shut tight.

(She suddenly kneels or crouches and begins to pull up handfuls, armfuls of the blossoming weeds, tearing at it with one strong hand, gathering the long stems into her other arm like a bouquet.)

But I know all about you. And so I cannot let you live. My old friend Don Juan Sanchez says to me, "Beware anything which is too beautiful in this barren place, and the jimson weed in particular. If she has to put on such a fine show," says Don Juan, "then she must be up to no good." *(She looks down at all the jimson weeds she has gathered, then sniffs them.)* "The moon brings her out, like an old *puta* with every known disease, and she parades her painted flesh."

(She stands and smells the blossoms more deeply, burying her face in them; then she speaks in an erotic whisper, the "voice" of the jimson weed flower.)

"*Debo hacer*—I have to, I have to. I am poison inside. Nobody will pay to see or touch me. Not if they know. Nobody must know."

(Abruptly, she withdraws her face from the bouquet. Disgusted, a little frightened now, she throws it down on the packed earth of the patio, and steps back from the weeds.)

But Don Juan and I know. Don Juan knows your attraction, your power. He knew men, when he was young, who came to you in the moonlight, when they couldn't bear the things of this world any longer. Men who would bruise the trumpet of your throat and scrape up your juice, or roast your seeds to mix with *pulque*, or dry your leaves and smoke them—and then sit alone in some black place somewhere, and shiver and faint, and come to again, in another place entirely, and would see animals which men are not meant to see. *(She listens: distant piping or singing.)* A mountain lion with a woman's singing face imbedded in its back. An eagle with soft feeble claws like a baby's hands. An antelope with a whole forest sprouting from its head, darkening the air for miles around. Alone, with only the jimson weed driving them, poisoning and guiding their blood, they saw new things, moved into new places, had new relations with new creatures. Alone.

(She squats down and fondles the jimson weed again for a moment, then tastes the palm of one hand. After another moment, she tastes her other palm.)

It will kill a full-grown steer, Don Juan says, in twenty to thirty minutes. The forehead starts to throb. The pupils roll back in the head. There is vomiting. And unbearable thirst which leads to more vomiting. The entire organ of the skin, scalp to foot, prickles with a green flame, seen and felt. The earth trembles under you, or is that you trembling so hard that you are shaking the whole earth? Your head lolls back at an unnatural angle, which is now the only possible one. And you die. But you die—having seen new things—with your new insides.

(She stands, licks the palm of each hand again, more thirstily, then looks up at the moon.)

The Faraway Nearby 17

I know. Might be just the medicine I need tonight. Jimson weed loco. A new way of seeing, a new life from the ground up, from the beginning. I want—I want not to have been born in Wisconsin! Probably a lot of people want that. I want to have been born in— out in Chaco Canyon. This land which is so native to me would really be native. Nobody could ever say again, "Oh, her. She's just some strange old visitor." They'd have to say, "She grew up out of this earth like those goddamned jimson weeds. She's one of the old cliff dwellers, a mountain and desert animal by birth." Yes, that too. Not to be born in Wisconsin and not to be born human— but just to stand out here on the high desert floor and make a sound so pure ...

(She licks the palm of one of her hands again, slowly, thoughtfully; then she sings a wild phrase of music, unrecognizable, which starts very high and descends very low. Then she stops singing suddenly, shudders, looks at her hands, tastes a bitter sting on her lips and in her mouth, and shudders again.)

Christ, what am I up to now?

(She moves back to the pile of uprooted jimson weeds, looks down at them, then jumps into the middle of them, and tramples them violently, rhythmically, until she is out of breath.)

Don Juan Sanchez—I am not letting her get to me, old friend! I am trampling out the vintage! I am playing the part of the fierce Christ that you and your Penitente brethren adore! I am thrashing the disease out of her, just like you New Mexico natives thrash the sin out of your stubborn red flesh! Isn't it good, isn't it fine?!

(She stops trampling, exhausted, and steps away from the crushed jimson weed stalks.)

Anyhow ... it's too late to start over ... I'm too old to rearrange or re-upholster or sell off the furniture in my old brain ... I'll have to settle for this decor, forever ...

(As she starts back into her house, she feels that her feet are wet and sticky with jimson weed juice. She stops, leans against something, and looks at the dark red sole of one foot, then the other.)

Disgusting ... Deadly ...

(She smiles, then laughs right out loud. She goes into the house, crossing through other rooms toward her bedroom. She sings,

and we recognize the odd melody she intoned before: Duke Ellington's "Don't Get Around Much Anymore".)
"Been invited on dates ...
Might have gone, but what for? ...
Awfully different without you ...
Don't get around much anymore ..."

(There is distant piping, a Penitente pito melody, somewhat closer now, which blends with Georgia's voice for a moment, then fades to silence.)

Scene Three:
Morning at Home

(GEORGIA smells something fragrant, flavors blended just enough, and races from her bedroom into her kitchen [which we probably don't see]. Now she is wearing a simple sombre-colored house dress, and her hair is caught up in a black kerchief.

She returns from the kitchen almost immediately, excited, carrying a plate of huevos rancheros [it would be good if we could smell them], a fork, and a napkin.)

GEORGIA: You have to get the real New Mexico Reds. I sometimes drive all the way to Chimayo or even Truchas. Down along the flinty banks of the Chama, or up on the chalky hillsides just before they crumble away into eternity—that's where you find your true New Mexico Reds. There is absolutely no substitute.

(As she crosses the threshold onto the patio, she stops dead still and listens.)

What? What did you say?

(She looks around, listens intently for another moment, then relaxes, comes out onto the patio, sits on the low stone step, where she was in the beginning, and eats her breakfast.)

Even a dried New Mexico Red is better, I suppose, than some flabby old *jalapeño*, like I've seen some people use. Stupid people. But nothing, nothing out of a can or a jar. Listen to me: there is no such thing as a canned pepper. A *poblano*? Now, I know some people who swear by the *poblano*, but I find it too easy on the tongue, and either leathery if it's not roasted long enough, or mushy if it's roasted a bit longer. The eggs don't appreciate having

The Faraway Nearby 19

to bed down with a *poblano*. I tell Maria, "You find me a New Mexico Red, or I'll just dream about *huevos rancheros* until you do."—Okay. You have to do the tortilla first, in lard not in oil. Some say duck fat, but I say that's pretentious. Then you take it out, keep it warm but not hot, so the grease eases into the pores of the corn flour—stealthily—like a boy with his tongue for the first time tasting the skin behind a girl's ear. Then, in another little pan, you start your chopped onions and garlic, in corn oil with a thumbnail-size piece of butter, I like lots of garlic, and when those get soft and golden, the chopped tomato—and the famous New Mexico Red, I like big surly pieces of it, not the mingy little minced bits they do at cafés. Salt and pepper. Meanwhile, in the same pan where you did your tortilla, melt another thimbleful of lard and fry your eggs just as you like them. I like them a little crisp at the edges—looks like a dirty old lace doily. By this time, your tortilla's luke-warm and soppy, you slide the eggs onto it and drown them in the sauce, then let it stand for about three minutes, so the flavors become acquaintances but not friends, then eat it up in a hurry, in a decent hurry, not like a truck driver—though I do like truck drivers—and wash it through your system with a second cup of coffee.

(She has finished eating by this time, and wipes her mouth contentedly with the napkin.)

Coffee.

(She stands and starts inside with her plate, etc. As she crosses the threshold, she again freezes, exactly as before.)

What?

(Still carrying her plate, she steps backward, away from the threshold, and looks under the low step up from the patio.)

Aha. I'm not losing my mind after all.

(She backs away onto the patio, sets her plate, fork and napkin down carefully on the ground, then moves across the patio and locates a long-handled hoe. She moves slowly, steadily back to the patio doorway. As if anticipating her, a desert rattler starts up a considerable racket, under the doorstep.)

That's right. Thatagirl. They say your eyesight's not much better than mine, but we smell plenty with the rest of us, don't we?

(She laughs. She holds the hoe up high and crouches at a healthy distance from the doorstep, peers into the shadow

underneath it. *The rattler continues its racket, settling into a slower but still intense rasp.)*

Well, you're beautiful. Another hour and I'd have found you lying out here, sunning yourself. I like the way the sun settles in that doorway too. But I staked a claim to it before you did. You know what my old friend Don Juan says. "Beware. It's the beautiful things that will kill you out here."

(She lowers the hoe slowly and reaches into the shadow with it. The snake's racket suddenly doubles in volume and rate, and obviously it strikes at the hoe, which GEORGIA draws back for a moment, reconsidering her strategy.)

I said to him, "Don Juan, if the beauty of these hills and this light hasn't killed me off in the past forty years—a girl like me from the featureless Midwest—then nothing can!"

(She begins to extend the hoe, slowly, toward the snake. The rattling crescendoes, then is suddenly silent. She withdraws the hoe halfway, peers under the step.)

Oh no—oh no, you don't!

(She drops down, flattens herself on the packed earth of the patio, and crawls in under the patio step, extending the hoe in front of her.)

You're not starting a family under my front porch!

(The rattler noise begins again, further under the porch. Most of GEORGIA disappears under the step too, all except her legs and feet, which we can see twitching expertly, as she reaches for the snake with the hoe. Rattling crescendoes, then is silent; she's got the snake. She scoots backward, out from under the porch step, and quickly gets to her feet, drawing the snake out after her, on the head of the hoe. In one more swift graceful movement, she swivels and tosses the rattler off the hoe, out beyond her low stone fence, onto the steep slope of the arroyo. Rattler noise starts up again, at a distance, then quickly fades to silence. GEORGIA moves to the fence, brushing dirt from her clothes. She peers off in the snake's direction.)

You're just lucky it was me and not my dogs that found you. They only know one way to get rid of a snake, and it's not pretty.

(She puts the hoe aside, picks up her plate, fork and napkin again.)

They're still asleep though. I took the ginger right out of them yesterday, running through The Faraway. *(She goes into the house, calling to her dogs.)* Jingo? Where are you? Bo? I just had to tangle with a rattler, all on my lonesome. A big one. Diamondback. Six or eight ivory blossoms on his tail, plus a button. *(She goes into her kitchen and can be heard talking to her dogs.)* You should've seen him, you should've heard him. I tell you, that is the desert's sweetest music, bar none. I like it even better than the mourning dove, or the orchestra of locusts.

(A shrill phrase on the pito, a primitive pipe, calls a procession of Penitentes to musical prayer. They are quite far away, starting up a steep hillside, but with voices raised so sharp and earnest that they invade Georgia's house. Delighted, she runs out onto the patio again.)

Hallelujah—I'm a damned liar! The Penitentes sing sweeter! Sweeter than a diamondback or a dove.

(She looks out toward the distant hillside, sending her thoughts strongly to the Penitentes.)

Yes! Strike hard at it—the animal part. Draw its blood! Because you respect that blood—even though you know it stands between us and a higher, cooler truth. Bear down with those knotted whips on the flesh you have already scored with flint. Climb and climb, your voices forced up the hillside ahead of you, toward Calvary. Sing to each other, sing to Him, sing to me. And I will answer you right back with the music which works on me and drives me up!

(She runs inside the house, to the radio/hi-fi console, and starts the same record as before, Bach and Casals. She turns it up as loud as it will go, then returns to the patio, races to the fence at one side, peers and squints to see if she can see the procession of Penitentes.)

They never look this way. But I love to think they can hear Bach and Casals answering them back—in a different dialect, but it's the same cry: "God, oh God, make this earth, this time go quickly! Fill it with enough beauty that we can survive its horror, and then take us swiftly to a cool even land!" They never look this way. And nowadays they wear shirts and trousers like everybody else. But underneath the shirts and trousers, they have bound spurs of cactus and belts of barbed wire. If you were close enough, you could see the blood dribbling down from their shirt cuffs, collect-

ing around their thick waists, sprinkling down from the mouth of the unhemmed trouser leg onto the red New Mexican earth—singing and saying to that earth, "Don't be so dry. Don't be so hard. Don't be so stingy."—and, at the same time, "God, oh God, I love the stinginess, I love the hardness, the dryness! Send us more!" Send me more. I love it too. I cannot live in an easy land. I cannot live in an air-conditioned reinforced-concrete place. I cannot live with other people! I cannot stay awake in those clean, convenient spaces.

(By this time, the Penitente voices have faded. GEORGIA listens keenly for a moment, then turns and hurries into the house, and stops the record. Then she comes back out onto the patio, moves back to the fence, and stares off.)

I don't hear you anymore, I don't see you. Are you up there? Are you binding the most beautiful of your young men to the huge rough cross? Raising it into the light and the heat? Crawling through your blood and His blood into the Savior's shadow, to confess everything?

(Pause. Then she turns away thoughtfully and moves across the patio. Maybe she stops to pick up trampled jimson weeds and toss them into a bin. Then she goes to the patio doorway and calls toward the kitchen.)

Bo?—Jingo?—Are you two going to sleep forever? We've only got two more weeks before hard frost and the first snowfall. Let's go. Let's get on out to The Faraway. Let's go to it!

(She whistles and/or claps for the dogs. Without waiting for them, she moves out onto the patio, to the edge of the light. After a moment, her two chow dogs are heard wheezing and panting. They run from the house, out across the patio, circle noisily around her for a moment, then race off ahead of her and disappear—maybe we track them only by their noise. At the same time, the setting behind GEORGIA changes from the house, the patio, and their relatively tame surroundings, to the desolate wildness and hard beauty of "The Black Place", Georgia's favorite retreat, in Navajo Country, northwestern New Mexico.)

Scene Four:
Noon at The Black Place

(GEORGIA is standing in a narrow box canyon. Cliffs rise all around, black, gray, dirty ochre, smudgy gray-pink. [For a sense of the space, consult O'Keeffe's several paintings of it.] Maybe she has put on a loose leather jacket and a Western hat. She is calling her two dogs, who can still be heard, their ecstatic coughs and throaty liquid yelps receding into the distance, echoing weirdly back through the canyon.)

GEORGIA: Jingo!—Don't you take him too far out there!—He's not like you, he's younger, and he never was very smart! *(She laughs.)* He's younger ... Doesn't know there's such a thing as danger ... especially in The Black Place.

(Dog sounds fade, and are soon gone. GEORGIA smiles uncertainly, looks all around. She moves to a twisted dead mountain juniper, and takes a large pad of paper and a leather pouch of pencils from a box or case she has hidden nearby. She looks all around again, then sits beneath the dead tree, takes out a pencil, and prepares to sketch, but doesn't.)

The Black Place.—Dear Red: Wish you were here. *(She laughs.)* Not really. I need to get away from all of you. From red and green and white and adobe and violet. Test myself out here—faraway—against the relentless blackness. I always liked that. Still do. "It will make a better person of you," my mother used to say to me, shutting the door behind her, leaving me—she didn't know how happily—all alone for the rest of the afternoon and the night.

(She leans the large pad of paper against the dead juniper, anchoring it with the leather pencil pouch. She stands and looks up at a thin discolored crease which runs from the high lip of the dark box canyon, all the way down to a ragged fissure at its base. This vertical crease is tinted in a different spectrum of smudgy sombre colors for its entire length.)

That used to be a waterfall. *(She moves closer to inspect it.)* I don't mean a million years ago. I mean when I first came out here to work. So: maybe half a million years ago. *(She laughs.)* Maria and I would load up the Model A—God, I wish I'd kept that lovely old thing—we'd load her up with brushes and paint and canvas and blankets and egg salad sandwiches—and rattle ourselves on out here to this hard lonesome glory. I'd make Maria go off and look

for interesting bones, or loose brush to make a fire—but really I just wanted to get rid of her, so I could be alone with the blackness, with the splash of black water spilling out of the white sky way up there, spraying down onto these gray rocks and sprinkling the black dirt—and, if I didn't get too taken with it even to try and paint it, then I'd try and paint it. Always loved it. Still do.

(She moves up through brush and boulders, and touches the smudged crease in the canyon wall.)

A few years from now, a hundred years or less, they'll never believe you were a waterfall. Or, if they do, they'll say, "Oh, but that wasn't remotely within the human era. No man or woman ever saw the water that carved and colored this crease. Not even the oldest of the cliff dwellers. Perhaps a sabre-toothed cat or a giant winged lizard drank here, but it never served a human creature." Stupid people.—Maria would stumble up here and fill her old black pot with water, and boil the coffee till we could smell it starting to burn, and we'd sit by the brush fire, the two of us, and drink the whole pot, and talk about the men in her life, her husbands and sons and grandsons, and the others, and about the men in my life, old man Stieglitz, and the others. And she'd say to me, "Miss O'Keeffe, you've had a lonely life." And I'd say, "Maria, a life with only a couple of handfuls of men and women scattered through it is not necessarily a lonely one. Maybe it's hard and dry and stingy, but only because that is the way I wanted it. I liked the challenge of it. Still do. Why don't you go load those bones into the Ford while I do some work?"

(She moves back and sits beneath the twisted juniper, takes up paper and pencil, and prepares to sketch—but doesn't. Nearby, a mourning dove begins its inimitable soothing lament.)

Mourning dove. I should answer her back. But I can't remember that old song about the mourning dove. *(She turns abruptly and calls.)* Jingo?—Bo?—Jingo! Where have you taken him? You old devil, you'll get him killed out here. *(Pause.)* The Black Place. I am lonely. Sentence from some stupid biography: "After eighty-odd years or so of perfectly contented aloneness, she found herself ..." Lonely. For the first time. *(She calls, but not very loud.)* Jingo? Don't you—don't you dare come dragging any snakes or pieces of snakes back here to me. *(Pause.)* The Black Place. Navajo Country. But the Navajos stayed away from this end of it. They still do. This is where you could come to die. To take jimson weed into

your mouth and stomach and blood, close your eyes—and when you open them, the old world and ways are gone forever, and you're alone, with your insides out—which are now new insides— or insides which were buried so deep that they never showed themselves in the light before. But now they do, here in The Black Place, where you forget all the songs you ever knew, and you are left perfectly alone. You forgot and left your heart in the pocket of your other coat. And your brain? "Damn, I forgot to take it off the shelf and wind it this morning." And all your other usual old comfortable insides—and the well-tailored suit of flesh and bone you usually wrap them in—everything familiar got left behind, or scraped off, or gets burned away in the wind that whistles through this black space out here. *(Pause. She suddenly calls, very loud.)* Jingo ...!

(She moves back, sits beneath the juniper, picks up the pad of paper, stares at the blank top sheet, then tears it off, crumples it violently, and throws it aside. She looks at the next top sheet, blank; she tears this one off, crumples it and throws it in the opposite direction. She looks at the next top sheet. Pause. She tears it off, crumples it, throws it straight up in the air; then, as it plummets back down, she bats it as hard as she can, away from her. Then she picks up the leather pouch and dumps it, scattering various artist's pencils before her. Methodically, she picks these up, one by one, and snaps them in half, then brushes or kicks the remains away.)

You can buy a picture post card of this old face in any museum or bus stop in New Mexico. The official phony stony grimace. Quite a few in Arizona and Utah as well. Other places too. I am famous as God or death, and just as alone, and I earned that, *on purpose*, by keeping my life clean of people and hobbies and biographies and appointments. And people. Keeping especially The Black Place, inside me, empty. No footprints. No more specially remembered voices I can imitate flawlessly, or hair I can still smell years later—not since my old man—half a million years ago. Just one long proud blackness and blankness. *(Pause.)* Except I'm not proud. Not anymore today. Here, where it stares me right back in the face. I am three-quarters blind to what it all meant. And lonely. I'll say this—I'll say it in a whisper, softer than a jimson weed offering herself to you in the blur of the moonlight: "I am not glad. Alone. I've come to the end of that pride in myself. I am only

alone. I am no longer glad." *(Pause. Then, even softer, and somehow erotically, she whispers.) Debo hacer,* I have to, I have to ... Nobody must know ..."

Part Two:
Days With Juan (1973–1984)

(There is a distinct fade to black at the end of each scene in this Part. Each of these blackouts lasts slightly longer than the previous one.)

Scene One:
Afternoon at Home

(As in the beginning: Georgia's patio, with clumps of sagebrush; her adobe house, and the adobe-like hills around it.

GEORGIA is in the room with the large window. A large blank canvas is on an easel at one side. She is dressed casually for work. She is staring at the blank canvas while she loosens the braid in her hair. The same Bach Sarabande performed by Casals is playing on the hi-fi, rather loud. A wedge of sunlight invades the room through the patio door. GEORGIA has not turned on any lights in the house. It is much brighter outside than in.

A tall young man vaults over the fence, moves to the doorway, steps up, and invades the wedge of sunlight. Almost immediately, GEORGIA feels the change in the light. She stiffens, swivels and frowns at him. He is lit brightly from behind; she sees him only as a dark shape.)

GEORGIA: Who are you? Who is that?

JUAN: That's Casals, isn't it? The Bach Suites. Which one?

GEORGIA: Stay where you are.

(She goes to the hi-fi console and stops the record.)

JUAN: Miss O'Keeffe?

GEORGIA: *(She turns back and peers at him.)* Who is it? What do you want?

JUAN: Miss O'Keeffe—

GEORGIA: Yes, all right, you found me. The light is so strong around you, I can't—What do you want here?

JUAN: I was just wondering—

GEORGIA: Wandering?

JUAN: *(A smile in his voice.)* Well, yes, that too, for quite some time now. But I was *wondering* if you might have any odd jobs.

GEORGIA: Odd? What's that supposed to mean? What did they tell you about me?

JUAN: I was here twice before.

GEORGIA: Who told you? Who's been talking?

JUAN: Everybody. People never stop talking about you, Miss O'Keeffe.

GEORGIA: I don't know any of those people and they don't know me. I'm alone. I've always demanded that. Still do.

JUAN: That's why I thought you might need somebody. Just for this and that.

GEORGIA: Step away. Step back from the door. I can't see who you are.

JUAN: I was here twice before.

GEORGIA: So were a lot of other stupid people. No, don't step in. Did I say for you to step in? Step back out into the light, out there.

(He laughs and takes a step or two back, away from the patio door. He can be seen better now. He wears boots, jeans, a mulberry-colored T-shirt and an unbuttoned work shirt, none of them very clean. His long hair, very dark, is in a pony-tail.)

JUAN: And I heard you'd been having some trouble with your eyes.

(She moves closer to him, as one hand continues irritably to untangle her hair.)

GEORGIA: *My* eyes: *my* trouble. I can see you well enough now.

JUAN: I notice you've got some crates around back.

GEORGIA: How'd you get around back? You're lucky, Maria's taken my dogs out for a run.

JUAN: I know. Otherwise I wouldn't be here.

GEORGIA: You wouldn't still be wearing both your legs.

JUAN: I know. I was here twice before. I've been doing some work for Jim around the ranch, since last fall. We were here once to see about your water heater. But that's all done now. I noticed those crates. You must be getting ready to ship some of your work somewhere.

GEORGIA: You don't know anything about my work.

JUAN: That's where you're wrong. If I close my eyes right now— *(He does so.)*—I can see half a dozen of your paintings, clear as anything. Some of them I haven't really looked at for years, but they come back to me, sharp as that, when I close my eyes. There's one in a museum back East, of red hills, like an old fence or a wrinkled skirt around the sharp black mesa. Except it's not really red. I don't know what you call that color. And there's one I saw hanging on somebody's wall in California. Jimson weed. Big white flowers with long white whiskers curled back from the mouth, and a green flame, like the flame off some strange chemical, down in the throat. Like a cold flame. But you want to be in there with it anyway. That's a truly strange one. I looked at it and thought, "She must be a strange one, O'Keeffe." Because it was all white, all glowing white crowded up into the foreground, into my face. But the first word I thought of, as soon as I looked at it, was "darkness".

(Pause. She looks at him. She has stopped playing with her hair. She pushes it back from her face, behind her shoulders.)

I know how to package and crate and ship a painting. I was studying art out West, before I started teaching pottery and ceramics to beginners, before I started driving truck for a while—and other things. I worked with Takemoto, you probably know him, Henry Takemoto. I used to pack and ship his stuff all over the world. Ceramics. There is nothing trickier I know of than packing and shipping ceramics. I'd do a good job with your stuff.

(She looks at him for another moment, then turns and goes into the house. She starts the Bach/Casals record again, turns it up even louder, then comes back outside, stops on the doorstep, and looks at him. He smiles.)

GEORGIA: Yes. It's Casals. The second Suite. D Minor.

JUAN: *(He nods and closes his eyes, listening.)* D Minor.

GEORGIA: You'll find everything you need for two crates—one twenty-four by thirty, one twenty-two by eighteen—out back there. I want them done by this evening and I want them done well. You'll only come to my place when I request you specifically. For this and that. There won't be more than four days a week of work, I mean ever, and I don't know how long that will last. You won't ever drink before coming here or bring liquor onto the place. You will have a bath or shower on each occasion before you come here. You will wear both a shirt and boots. I don't pay for injuries. I keep the whole place clean, so you shouldn't have any excuse for getting injured. I'll pay you whatever Jim Hall was paying you. And don't think I won't ask him how much that was, and about you in general. What is your name?

JUAN: Hamilton. Christened "John", but I like to be called "Juan".

GEORGIA: Juan Hamilton. It's like a name you make up when you're seven years old and you're going to play pirates. I like that.

JUAN: Well—I like the Bach. D Minor. A good key. It always makes me think about the twilight.

(They stand looking at one another for another long moment, then he turns and goes off behind her house, singing an approximation of the Bach melody to himself. She watches him go.)

Scene Two:
Night at Home

(In the room with the large window, GEORGIA is sitting on a bench, leaning back against the adobe wall. JUAN is sitting on the floor, near her feet, leaning back against the bench. He now wears a better quality shirt, jeans, and boots, and his hair is pulled back with a leather or silver band. They both sip pale amber liquid from clear glasses, as he reads back a letter she has dictated.)

JUAN: "Please let me reiterate that under no circumstances would I want you to use my name for your new Arts Center, even if it is in Wisconsin, without first having me visit the space, or at least letting me inspect a blueprint of the plans. This may strike you as obtuse or belligerent, but I have been around almost as long as Wisconsin has, and I'm sure it's too late for either of us to change now. Sincerely, Georgia O'Keeffe."

(He looks up at her.)

GEORGIA: Good. That's fine, that's good. Send it tomorrow.

JUAN: Right.

GEORGIA: Special Delivery or Registered or something. I don't want them to say they didn't get it and so just went ahead without my permission.

JUAN: *(He stands.)* Right. You want more?

GEORGIA: More letters? Not tonight.

JUAN: More tequila?

GEORGIA: Not tonight. It's good stuff.

JUAN: It is good stuff.

(He pours more for himself and knocks it back, while putting the letter away.)

GEORGIA: Maria would have a conniption fit if she saw me sitting here, sipping. And my sisters would have me thrown in the asylum, or in a convent.

JUAN: In a convent? I like that picture. I can't imagine any order of nuns that could tolerate you for more than a week.

GEORGIA: A week? I'd burn the place down the first night. Except the chapel. I like those old chapels.

JUAN: Me too. It's almost enough to make you turn Church of Rome, isn't it? I'd love to have my funeral in one of those messy old holy places. Not in some fake plush and beige plastic Protestant prayer palace.

GEORGIA: Do you plan your funeral sometimes?

JUAN: Sometimes. Do you?

GEORGIA: You've got a hell of a nerve, asking a creature my age such a leading question. No. I just want somebody, somebody who loves this land like I do, or almost as much, to take my ashes out and sift them into The Faraway, out there. I like to think about myself, swirling around these hills, and being lifted up high by the dust-devils, and learning what that red really is, from the source.

JUAN: I'll see to it.

(He drinks more tequila.)

GEORGIA: *You* will? Oh, I don't expect my sisters will let you anywhere near my ashes. Or anything else.

(She stands, stretches, and moves out onto the patio. He follows her out, with his glass of tequila.)

JUAN: Why? What would they say to me?

GEORGIA: At my funeral, you mean?

JUAN: Yes. One of your sisters comes up to me—

GEORGIA: Claudia.

JUAN: Sister Claudia comes up to me and says …?

GEORGIA: *(She mimics Claudia's voice.)* "You shouldn't be here. This is a family observance. You're not family."

JUAN: "I'm a friend though."

GEORGIA: "A friend? Georgia didn't have any friends your age. What would Georgia have wanted with a friend your age?"

JUAN: "I did stuff for her. This and that."

GEORGIA: "Oh, you were the hired man. I thought you said 'a friend'."

JUAN: "Georgia allowed me to be both."

GEORGIA: "And did she permit you to call her 'Georgia'?"

JUAN: "Not when I first came to work for her."

GEORGIA: "Aha."

JUAN: "Not until a whole week had gone by."

GEORGIA: "Don't lie to me, young man, with my sister lying right there in her casket!"

JUAN: "I thought she requested cremation."

GEORGIA: "Georgia ran roughshod over this family her whole life. It's our turn now."

(JUAN laughs. She looks at him in the moonlight, then speaks in her own voice.)

I think you'd be wise just to steer clear of my obsequies. And my sisters. Especially Claudia.

JUAN: Not at all. I'm looking forward to meeting her.

GEORGIA: You just think you are. *(She looks around the patio.)* We finally killed it off—the jimson weed. I had a hell of a time with it out here. I'd pull it up, I'd chop it down. And then, there she'd be again, whispering to me through these solid walls, sending her perfume in to tease me. But not since you came.

JUAN: I grew up with jimson weed in Texas and in Mexico. I know there's only one way to discourage it permanently.

GEORGIA: How?

JUAN: That'd better be my secret. If you run out of shipping orders and correspondence and windows to be reset and walls to paint, you'll still have to keep me around, to wrestle with the jimson weed.

GEORGIA: Did I tell you what Don Juan Sanchez told me about the jimson weed?

JUAN: Yes.

GEORGIA: I've taught you a lot of things.

JUAN: Yes, you have.

GEORGIA: Did you ever wonder why?

JUAN: I know why.

GEORGIA: Tell me.

JUAN: Because you like my name.

GEORGIA: Juan Hamilton.

JUAN: Yes.

GEORGIA: Yes, I do like it. It's a name that could only come from this time. It's a name with its hands crammed into its back pockets and its hair in a pony-tail. And with a soft voice, like those records you played me.

JUAN: Baez.

GEORGIA: I grew up in Wisconsin, in a world of hard-voiced names. Herbert and Thomas and Arthur and Alfred. I never liked it, that my old man's name had to be Alfred. I never called him Alfred. Just Stieglitz and, once in a while, "my old man" or "Papa". He didn't like that much. But he did like the mood I was in, when I used to call him "my old man".

JUAN: When the two of you were close?

(GEORGIA nods, and looks up at the moon.)

When you loved him?

(GEORGIA nods again.)

Was he the only one, Georgia? Ever?

(She turns and stares at him.)

I mean, was he the only one you ever loved like that? Like a woman loves a man?

(Pause.)

GEORGIA: You've got a hell of a nerve.

JUAN: Why?

GEORGIA: Asking me that.

JUAN: About your old man?

GEORGIA: Mister Stieglitz to you.

JUAN: For Christ's sake, he's not here. He's dead, Georgia.

GEORGIA: Miss O'Keeffe to you.

JUAN: We talked about him before. We figured out I was born in the same year, in the same season even, that your old man died.

GEORGIA: Who are you? *(She goes into the house.)* I don't even remember who the hell you are tonight.

JUAN: *(He follows, only as far as the doorstep.)* Yes, you do.

GEORGIA: *(She looks around the room.)* What did you do with that canvas, the one I was working on this afternoon?

JUAN: You told me to put it away. And that was three days ago.

GEORGIA: Liar.

JUAN: You said you couldn't stand the sight of it.

GEORGIA: Liar. Who are you? *(She moves closer to him.)* I hired you. I had you into my home to work, to help me out. I opened up all sorts of places in my life, so you could help me. Do you know how many others could claim I ever let them in? After Stieglitz died, a century ago? Stieglitz liked people. I detest them.

JUAN: Maria—Candelaria—Eva—Beatriz—

GEORGIA: How many *men*? I'm talking about men! You know how lucky you are, young man? Do you have any idea how special a space I made for you, close to me, to trample around in?

JUAN: Yes, I do know.

(He moves back out onto the patio.)

GEORGIA: Where are you going?

(She follows as far as the doorstep.)

JUAN: And I know the real reason why you made space for me. *(Pause.)* You're sure spooky tonight, Miss O'Keeffe. You're sure

feeling your oats. Is that because it's a full moon? Imagine what a tribe of jimson weed blossoms we'd have out here tonight, if you hadn't made me get rid of them. *(He turns back and looks at her.)* That painting I was helping you with, that was three whole days ago. The red door into the deep white shade. It was this patio—this patio on another planet. Remember, you laughed when I called it that? We were putting in the rectangles of your red, together. "Name this red," I told you, "name it right now, right here in front of me." And you got that look on your face, like a seven-year-old defying her first-grade art teacher. "Black." You said, "Black." And when I made a face, you smacked me on the forehead—like that—with the flat of your hand.

GEORGIA: Well, they allow that kind of blow in wrestling. Harder than I meant to. Big tears started to well up in your eyes.

JUAN: That wasn't pain. It was—because it was the first time you ever laid a hand on me. Touched me.

GEORGIA: Was it? I don't think so.

JUAN: Don't you think I'd know? *(Pause.)* Where's that tequila?

GEORGIA: In here.

JUAN: You want to bring it out? *(She doesn't move.)* The full moon says, bring it on out here.

(She goes in, fetches the tequila bottle, and starts outside. He calls to her.)

And bring your glass too.

(She stops in her tracks, then, after a long pause, she picks up her glass and brings it outside too. She moves to him. He takes the bottle, pours more into his glass, and a bit into hers. He doesn't drink. He looks up at the moon.)

This is one of your jimson weed nights, for sure. A night when you just have to howl in a high high voice, all the way to the moon.

(He howls, then sings the Duke Ellington tune.)

"Missed the Saturday dance—
Heard they crowded the floor—"

(He looks at her.)

GEORGIA: *(She sings.)* "Couldn't bear it without you—"

GEORGIA and JUAN: "Don't get around much anymore ..."

36 John Murrell

(He laughs. She looks at him, sips her tequila, then touches his hair, the back of his neck.)

GEORGIA: I don't. I don't know the real reason why you're here. But I know I just made up my mind, that afternoon when you interrupted my light. In that doorway there. I made up my mind. And my sisters and my agent and any of those damned journalists could tell you, when I make up my mind, it's like Casals biting into his cello, or Truman deciding to drop that bomb. I made up my mind to let you in, to let you open up all the old chests and cupboards which none of these women, and sure as hell no other man, ever even got to peek into. Open them up wide, let some air and light, and the second half of the twentieth century, in!

(She stops touching him, looks at him, and drinks. He drinks too.)

About "my old man". I can tell you anything. What do you want to know?

Scene Three:
Morning at Home

(On the patio, JUAN has laid a wide smooth rectangular board across two sawhorses. He has set out various colors and quantities of clay on this board, and is now fiercely concentrating on building up one of his dark womb-shaped pots. He wears jeans, no shirt, no footwear. His hair is somewhat shorter now, but he wears it loose around his face, no pony-tail.

GEORGIA appears in the room with the large window, looks out and sees JUAN. She is dressed much as before, simply but expensively, her hair tied back in a kerchief, but she chooses slightly less sombre colors now: sienna, a rich nearly-black brown. She picks up something from a table, and comes outside, moves to JUAN, and reaches up to comb his hair.)

GEORGIA: Bend down a minute.

JUAN: Georgia, I'm trying to work.

GEORGIA: Bend down a bit. You look like the Wild Man of Borneo.

JUAN: Just the effect I was going for.

GEORGIA: Bend down.

JUAN: You can do that later. I'm working.

GEORGIA: Bend down.

(She pinches him.)

JUAN: Ouch! Damn it, Georgia—

(He frowns, then leans a little to one side, so she can comb his hair.)

GEORGIA: I used to put on a fresh blouse and a freshly pressed skirt, stockings and pumps, a fresh neckerchief and a big smart hat, when I was going to work, even if I was roughing it out to The Black Place.

JUAN: Well, that was you, that was way back then.

GEORGIA: Maria told me I was a lunatic. But I was a damned handsome lunatic. *(She moves to his other side.)* Bend down in this other direction.

(JUAN does so. She combs that side.)

I always think an artist's character is reflected in his work. And his grooming habits are a reflection of his character.

JUAN: You sound like my father. Except he's not too sure that artists have grooming habits, or character.

GEORGIA: I'll straighten him out. I'm old enough to be your father's mother.

(She finishes combing his hair.)

JUAN: You're old enough to be my grandfather's mother.

GEORGIA: Oh, shut up. *(She thumps him on the shoulder or head with her comb.)* I thought you were trying to work.

JUAN: I am. *(He goes back to his pot.)* Look at this. Can you see this?

GEORGIA: Of course, I can see it. I'm only three-quarters blind, you know. And some of you just can't wait till I lose the rest, can you?

JUAN: What are you talking about?

GEORGIA: I'm talking about dependency. I was the least helpless woman in the world for close to ninety years. You think I don't know how pleased you'll all be when I'm finally as needy as the rest of you?

JUAN: You're not making sense, Georgia. You're talking to somebody else again, not to me. And I'm working now.

GEORGIA: *(Her eyes move from his work to him again.)* Remember how short they cut your hair when we were in Jamaica? I loved it that way.

JUAN: It drove me crazy.

GEORGIA: You looked like a boy I knew at Art College. He was forever offering to pose for us, in the nude, in his spare time. For free. He was from North Carolina.

JUAN: Did you take him up on it?

GEORGIA: *(She shakes her head "No".)* We wanted to. But we suspected he had a hidden agenda. *(She laughs.)* Why don't you show me what you're up to there?

JUAN: Just look at it. You said you can see it.

GEORGIA: But I can't see it as well as I could with my hands. *(She touches him.)* If you show my hands. Remember, a couple of days ago when we worked on a piece together?

JUAN: That was a couple of weeks ago.

GEORGIA: You were teaching me the clay. I loved that. Picturing the earth *with* the earth.

JUAN: I'm into this piece of my own right now. Something just for me.

GEORGIA: I think I'm going to write to Claudia and say, "Juan is making me into a whole new kind of artist, Claudia. I may give up paint and start all over again in this new medium. And I think I'll buy back all my canvases, Claudia, from whoever's got them." She'll probably have a heart attack.

JUAN: Ssshh.

GEORGIA: Show me what it is, Juan. Let's work together.

(She moves close beside him and reaches toward the clay.)

JUAN: Don't, Georgia.

GEORGIA: Let me help you. You help me.

(She touches the clay.

JUAN turns, takes her by the shoulders, and swiftly, firmly moves her away from his work table.)

JUAN: Not now! This is something of my own. Can't you let me have that much? Maybe tomorrow, or Saturday, we'll do a little work together. *(He goes back to his clay.)* If you really feel like it.

GEORGIA: You didn't always talk to me like I'm seven years old, did you? I would've noticed it, that afternoon you moved into my light. And I would have had nothing to do with you.

(JUAN tries desperately to move his mind back to his work.)

I can smell the liquor on your breath. I don't know how you expect to work in that condition.—"You will wear a shirt and boots at all times." When did we amend that part of our understanding?—I wish I could recall the first time you ever introduced yourself as my "friend", not my "assistant". I'd like to know where I had mislaid my brains when I let that happen.—And I thought I was still paying you a little something. Am I still paying you a little something, Juan? For the past several months, and years? Or are you paying me now? Are you paying me for the use of my house and my studio and my patio and my car and my friends and my name? Mister John Hamilton?

(He takes a deep breath, wipes the clay from his hands, turns and looks at her.)

JUAN: I'll have everything out of here by this afternoon.

GEORGIA: Don't be stupid.

(He starts savagely, efficiently packing up his clay and clay-working paraphernalia.)

JUAN: I'll get Manuel to help me. We'll bring his truck around back. About three o'clock, if that's okay with you.

GEORGIA: Don't be crazy. I was just trying to get your attention.

JUAN: You got it. I'll move all my stuff back to the trailer, and you can request me specifically if you have any odd jobs for me. Just this and that. Unless I go back to Costa Rica for a while. I've been thinking about Costa Rica.

GEORGIA: God damn it, Juan. You know that's not what I'm after.

JUAN: What are you after, Miss O'Keeffe? You think I don't know how lucky I've been? You're wrong. You think this hasn't been heaven for me, every one of those years? You're wrong. It's been three-quarters heaven, Georgia. With only those occasional glimpses into hell, which I fully expected from somebody as strong-minded and alone and spoiled as you are. I haven't minded all that much, turning my hours into your hours, my sight into your sight, turning my whole goddamned life upside down. Because the payback was

a kind of freedom, and a search, and a true craziness I didn't even know was on the menu, before you.

GEORGIA: I don't appreciate the word "craziness".

JUAN: I know you don't—because now it's changed. It's all changed lately.

GEORGIA: No, it hasn't. How has it changed?

JUAN: Because you're not that strange huge woman I came up this hill to worship. Not anymore. I work, and you really can't work anymore. You could for a little while, when I first came here, and I could even help you. And I don't even remember whether you invited me to move my work and most of my life up onto the hill one day, or whether I invited myself. And it didn't matter a good goddamn whether you thought of it or I did, not just a little while ago. Because we were thinking and feeling and working as one animal. But not anymore. You're not a good friend and you're not a good boss anymore.

GEORGIA: What am I?

JUAN: You're just a lonely confused goddamned-difficult old woman.

(They don't move for a long moment. Then JUAN, feeling sick to his stomach, goes into the house, picks up his shirt from a bench, puts it on without buttoning it, picks up his Mexican sandals, and comes back out onto the patio, and looks at GEORGIA. She has not moved. He sits on the doorstep, to put on his sandals.)

GEORGIA: Juan Hamilton. Let's drive out to The Faraway this afternoon. I'll make egg salad sandwiches. We could go as far as The Black Place, if you want to. Did I ever take you out to The Black Place?

JUAN: Yes.

GEORGIA: I feel it whispering to me, teasing me: "Come on out here, old woman, if you think you've got all the answers. We'll just see about that." Juan? You think that's a good plan? Drive out to The Faraway, or even as far as The Black Place, and have a good talk on the way? Or just be quiet, by ourselves, and have a good think?

JUAN: I don't know, Georgia. I don't know if I remember how to think anymore.

(GEORGIA laughs and, at the same moment, a shrill pito phrase calls from a distant hillside. GEORGIA catches her breath, listens. JUAN does not react. Now the pito accompanies a crude crooning Penitente hymn, men's voices only, far away, struggle and pain in their voices. GEORGIA looks at JUAN who is resting his face in his hands or looking away. She rushes to one side of the patio, peers and squints out beyond the fence.)

GEORGIA: It's them. *(She listens, then sends her thoughts in their direction.)* Strike hard at it! *(She turns back.)* It's them, Juan.

JUAN: It's who?

GEORGIA: The Penitentes. *(She turns and peers off again.)* They've brought out their whole parade of wooden saints and martyrs today. Must be a dozen or more, and look at the size of them! They've brought out their old green skeleton with her scythe and her huge evil grin, Death In Her Chariot, that's rare, that's a treat. It's not Easter, what is she doing out? Don't you want to see, Juan? *(She turns back.)* You can see and hear them better from over here. Death In Her Chariot. A once-in-a-lifetime opportunity?

(After another moment, JUAN gets to his feet and moves to where she is, at the fence. He glances off in the direction she is peering.)

JUAN: I don't see or hear anything.

(Instantly the pito and the Penitente voices are silent. GEORGIA peers still harder into the distance.)

I've never seen or heard them, all the times you've made me look. Jim Hall told me the Penitentes haven't been seen or heard around here for thirty years or more. He told me they closed down the last of their chapels in this valley, way back in the early sixties or late fifties, when the religious freaks and peyote smokers from the West Coast started to come around and bug them.

(She turns, looks at him, then turns again and stares off in the same direction.)

And Maria told me, if there are any more Penitente processions and mock crucifixions and flagellation, it's all so far up and so deep in these red hills that we white people would never even hear about it, much less get to see it.

GEORGIA: *(She turns and looks him in the eye.)* They were out there a few minutes ago. You scared them off. But they were out there.

42 John Murrell

In my world, they were. But you're moving out of that space now, aren't you, Juanito? Out of that search. Back into the other, the ordinary world, with all the rest of them. God, oh God, you came for a visit, and then you went away again so quickly.

Scene Four:
Noon at The Black Place

(The narrow box canyon—black, gray, dirty ochre, smudgy gray-pink—is empty; but now a narrow, confident stream of darkish water pours over the high lip of the canyon, exactly where it ran and discolored the canyon wall many years ago. This water collects in a shallow pool in the groin of the ragged fissure.

After a while, JUAN and GEORGIA make their way in slowly, with a picnic hamper, a blanket, and a battered six-string guitar. She is negotiating the rough slippery terrain with noticeable difficulty, trying to pretend that nothing could be easier. She is dressed rather fancy, similar to the first scene in the play, and he has on boots, shirt, trousers, and a hat too. We hear them singing, with little flourishes of primitive harmony, before we actually see them.)

JUAN AND GEORGIA:
"When you hear them cuckoos hollerin',
When you hear them cuckoos hollerin',
When you hear them cuckoos hollerin',
It's a sign of rain, buddy, it's a sign of rain!"

(They continue singing, as they approach the waterfall.)

"When you hear them hoot-owls callin',
When you hear them hoot-owls callin',
When you hear them—"

GEORGIA: Stop! I don't believe it. She's back.

(She frees herself from JUAN and moves to the waterfall. Laughing, she puts her hand into the water.)

I thought we'd seen the last of you. *(She turns to JUAN.)* This used to be a waterfall. And now it is again. *(She turns back to the water.)* Just look at you. As though you had never stopped punching in.

(JUAN has put the picnic hamper and guitar down, he spreads the blanket, just far enough from the waterfall to be out of the spray. She turns back to him.)
Oh, Juanito, I wish we could've brought my dogs. Jingo especially. He ought to see this before he dies or goes blind.

JUAN: You know they can't stand me, after all these years. Jingo especially. And he's virtually blind already.

GEORGIA: He keeps a pretty sharp eye on you, Mister.

JUAN: They'd have been sulking and groaning around all afternoon. I'm glad it's just you and me, Georgia.

GEORGIA: I'm glad it's just you and me too. Did you hear that other singer, as we came up the canyon? Mourning dove.
(She sings and dances, improvising restricted but enthusiastic steps and gestures.)
"When you hear them cuckoos hollerin',
When you hear them cuckoos hollerin',
When you hear them—"
(JUAN picks up his guitar, and starts to play along. GEORGIA stops.)
Uh-oh. That's not my key, Mister Stokowski. Does that thing sing in my key?

JUAN: I'll torture it until it does! *(He sings.)*
"When you hear them cuckoos hollerin'—"

JUAN and GEORGIA:
"When you hear them cuckoos hollerin',
When you hear them cuckoos hollerin',
It's a sign of rain, buddy it's a sign of rain!"

GEORGIA: *(She sings alone, picking up the tempo considerably.)*
"When you hear them hoot-owls callin',
When you hear them—"

GEORGIA and JUAN:
"—hoot-owls callin',
When you hear them hoot-owls callin',
Somebody's dyin', Lordy, somebody's dyin'!"
(She sings and dances alone, as JUAN improvises a more complicated and ever faster accompaniment.)

GEORGIA:
"Goin' up on the mountain for to see my baby,
Goin' up on the mountain for to see my baby,
Goin' up on the mountain for to see my baby,
An' I ain't comin' home, buddy, an' I ain't comin' home!
When you hear them cuckoos hollerin',
When you hear them cuckoos hollerin',
When you hear them—"

> *(She slips on the wet rocks at the base of the waterfall and tumbles into the shallow pool, making quite a splash.)*

JUAN: Georgia!

> *(He immediately puts down the guitar and hurries to help her. By the time he gets there, she has sat up in the pool and is laughing so hard she can't speak.)*

Georgia?

> *(She waves him away, doesn't need his help. She scoots to the rim of the pool and hoists herself onto the drier edge of it, still laughing.)*

Did you break anything?

GEORGIA: Only my concentration. During what was—without doubt—my greatest performance—of all time. *(She takes off her kerchief and her jacket, laying them on the rocks beside her.)* You know, I love your records—but I don't believe that Joan Baez repertoire is really for me. I'm more like—

JUAN: Esther Williams?

> *(He moves around the pool, to her.)*

GEORGIA: No. More the Tammy Wynette type, I think.

JUAN: Tammy?

GEORGIA: Well, maybe it's more how I feel when I'm singing.

> *(She takes off her shoes.)*

JUAN: You want me to hang your stuff on that juniper, to dry?

GEORGIA: I don't care. It's so hot today. It's the hottest it's ever been in The Black Place, right back to and including the days of the giant winged lizard.

> *(She struggles to take off her stockings.)*

JUAN: Were you around back then?

GEORGIA: Oh yes, the sabre-toothed cats and I used to bring down a lizard or two for supper. Great sport.

(He watches her struggle, then suddenly wades into the pool, boots and all, and helps her remove her stockings. She is too surprised to speak. He takes her stockings, gathers up her hat, jacket and kerchief, wades out of the pool, and hangs her things on the twisted branches of the dead juniper. She watches him start to do this, then she swiftly unbuttons her silk shirt, takes it off and tosses it aside, unbuttons and unzips her black skirt and starts scooting out of it. A treeful of locusts starts rasping, in the near distance. JUAN turns and sees what GEORGIA is doing. He moves to the opposite side of the little pool, taking off his hat and tossing it aside. Then, just as GEORGIA is finally free of her skirt, down to her underwear, and is laying the skirt aside, JUAN drops his jacket, unbuttons his shirt, takes it off and drops it on top of the jacket. GEORGIA looks up at him, as his hands go to the top of his trousers. She slips into the pool on her bottom, and splashes him a challenge. He looks at her, unbuckles his belt, unzips his trousers and pushes them down below his knees. He is either down to his undershorts or naked, as he sits awkwardly at his edge of the pool, swiftly doffs boots and socks, and pulls his trousers the rest of the way off. Watching him, GEORGIA sings.)

"When you hear them cuckoos hollerin',
When you hear them cuckoos hollerin',
When you hear them cuckoos hollerin',
It's a sign of rain, buddy, it's a sign of rain ..."

(JUAN stands again and wades into the pool. Maybe GEORGIA splashes him some more. Then he wades up the fissure to the spraying foot of the waterfall, and stands directly beneath the cascade. GEORGIA stops singing and watches him. After a few moments, he steps out of the spray, splutters, shakes his head and shoulders like a dog, then looks at her. She laughs.)

JUAN: What?

(She splashes water up at him. He splashes her back with his feet and hands, and then suddenly comes and sits close, directly behind her, his legs on either side of her, his hands holding her hands down, so she can't splash anymore. They are both laughing. Their laughter gradually quietens, with a few sudden dis-

ruptive guffaws on the way to silence. Finally they are both still. Everything is still, except the locusts.)

GEORGIA: Juanito?

JUAN: What?

GEORGIA: You see that funny-looking gray-green cactus, right over there?

JUAN: I see it.

GEORGIA: You could get your pocket-knife and cut a piece of it for us.

JUAN: To eat?

GEORGIA: No, Dumbo. It makes a kind of soap. It's real good for your hair. Maria taught me. I think I'd like you to wash my hair.

JUAN: If I do, will you wash mine?

GEORGIA: I think I'd better. It needs it. It always needs it.

JUAN: I get that from my Indian ancestors.

GEORGIA: What Indian ancestors? You never told me about that.

JUAN: Yes, I did. Are you going to splash me, if I get out for the soap plant?

GEORGIA: No.

JUAN: What do you swear by?

GEORGIA: D Minor. And Tammy Wynette.

JUAN: I guess that's good enough.

(He stands shakily and dashes out of the pool, as fast as he can. He races to his trousers, locates his pocket-knife, and uses it to cut a piece of the gray-green cactus, which oozes a viscous colorless liquid from its cut end. Then he races back toward the pool. Just as he reaches the edge, GEORGIA splashes him mightily with both hands.)

Damn it, Georgia—

(She tries to splash him again, but he is too fast, gets in behind her and sits, as before, where she can't get to him. He holds up the oozing cactus spear.)

Do you want your shampoo or not?

GEORGIA: I want my shampoo. I really do, Juan.

JUAN: And you need it.

(He squeezes cactus ooze onto her hair.)
GEORGIA: I know. That's because of my Indian ancestors.
JUAN: They were Irish and Hungarian.
GEORGIA: Ssshh. I'm working on my myth.
(He shampoos her hair, working it into a rather flat lather, then rinsing it by scooping water over her head with both hands.)
I won't ever come out to The Black Place again. My dogs are too old and blind to enjoy it. And I'm ashamed of how much help I needed to get up that last hill. Not to mention having to meander all over Creation to avoid—was it three different families of rattlers?
JUAN: Two.
GEORGIA: I would've walked right into the middle of them, if you hadn't been there. And you can't always be there, can you, Juan? Not anymore. Not every time it comes into my head to yell for you.
JUAN: No. Probably not.
GEORGIA: You've got so many other things in your life now. That girl.
JUAN: Yes.
GEORGIA: And your work. Which I am so proud of.
JUAN: You should be. It wouldn't have gone where it's gone, without you.
GEORGIA: I know.—I won't come to The Black Place again. This was a good, fun last visit. I came close enough to killing myself to get my old blood pumping like an oil well. A gusher. I sang and danced a little. And I got a good shampoo.

(He has finished her shampoo and rinse now. She sits very still, looking all around, as best she can.)

The Black Place is where you come to set yourself a test. Can you be that alone? Can you be there with only your insides for company? Your insides which take you more by surprise, scare you more, than they do anybody else. Every person has to set herself, himself that test. I have passed it with flying colors. I have passed it and passed it again. I only have to pass it once more, in my own mind, in my own time, and then I can go out and swirl through The Faraway forever. And you can't help me pass that final one, can you, Juan? You can't help me with that. And so, you can't help me.

It was lucky though, for both of us, to have felt we had each other these several years. Feeling that we actually have each other puts the beauty into people's days and nights. Even if it's only a fugitive, not a true, thing. What is that one true thing, Juan? Did I ever teach you that? Because, if I did, it's fallen out of my mind now. I wonder, could you teach it back to me?

Part Three:
Alone (1984–1986)

(As in Part One, there are no blackouts, only shifts of color, intensity, etc., between and within scenes, from this point onward to the end.)

Scene One:
Afternoon at Home

(The patio, the house, the hills, exactly as before. After a moment, GEORGIA, who has been lying down, invisible, on the roof of her house, stands up. There is no visible evidence of how she got up there. She wears a simple white nightgown throughout this part, and a black kerchief around her hair. At the moment, she is barefoot. She stares outward, turning in a slow circle.)

GEORGIA: Red. Red. Red all around. I still haven't gotten you. And so, I never will. I won't try again. I guess you feel pretty damned proud of yourself! *(She turns to face west.)* Navajo country out there. *(She turns to face south.)* Santa Fe out there. *(She turns to face east.)* Chimayo out there. And Taos. *(She turns to face north.)* Colorado up there, just over that spine of mountains. And Red has dabbed her face powder over every bit of it. Hundreds and hundreds of miles. She's taking over. And I have to let her. Forget her. *(She sits on the roof ledge, hanging her legs over.)* I took my nephew up there, into cold stream country, Colorado, a few years back. He was determined to make a fisherman. Luck of the Irish, he caught a huge trout, huge and young and beautiful, the first day we went out. I ran up the hill to stoke the fire, so we could have him for breakfast, fresh as the water he came from. Then I looked back down, to see how he was doing. My nephew is a city boy,

he'd never dealt with a huge beautiful fish before. He didn't know to strike it against a stone, or take its head off fast, before cleaning it. So he just took out this piddling little city-type pocket-knife, shoved it in right below the gills, and pulled the knife straight down to the tail-fin. I could hear the unzipping sound it makes. Then he pried it open and used the side of that piddling little blade to push its insides down and out. I came roaring down that hill to him, mad as hell. I hate city-bred ignorance, I hate unnecessary suffering. The necessary is bad enough. And I saw that the trout was still thrashing back and forth, and its eye was still working—long after its heart and its guts had been swept away down the stream. It had no more equipment to feel anything with. But it went on living—working—for a whole other minute or more. Its eye was saying to me: "I don't feel it. I know you think I'm struggling and that I am afraid. But I'm just thrashing around like this because I don't know how to stop. God, oh God, the worst of all is surviving without being able to feel it, or to stop." *(A long pause; she looks around the roof.)* Just now I was looking for birds' nests. The littlest kind of junco, I don't know what they're called, they sometimes build their perfect tiny nests up here. And I happened to look down into a bright stretch of wet, where the last of the frost melted this morning. What did I see, looking back? I leaned down close—the side of my face—and I saw that empty trout's eye staring back at me. Her last sixty seconds.

(JUAN appears from behind the house. He is dressed almost like a businessman now, Italian trousers and sports jacket, a beautiful cotton sports shirt open at the throat, shoes of Italian leather. His hair is shorter again, or combed to make it look shorter. He sees Georgia's legs. He sees GEORGIA. She sees him.)

GEORGIA: Who is that?

JUAN: Guess.

GEORGIA: *Buenas tardes*, Juanito.

JUAN: *(He speaks quite loud, as she has begun to lose some of her hearing.)* How did you get up there?

GEORGIA: I flew. I fly up here all the time, to watch the Red fading, to let it watch me fading.

JUAN: Really? I don't see your broomstick.

(GEORGIA smiles smugly, reaches for something on the roof behind her, lifts it and throws it down: a very old hand-made broom. He dodges, and checks to see if she's gotten him wet or dirty.)
What are you doing with that up there?

GEORGIA: I told you: fishing.

JUAN: You're not making sense, Georgia.

GEORGIA: Why not?

JUAN: Just stay right where you are. Don't fly off anywhere.

(He disappears behind the house.)

GEORGIA: Well, I never know when the whim may take me.

(After a moment, JUAN reappears from behind the other side of the house, carrying a primitive wooden ladder, the sort that seems more for show than for practical use. He leans this against the roof ledge, near where GEORGIA is sitting, and climbs up to her.)

Where were you, Juan? Earlier? I couldn't locate you. Were you off visiting your girl in town?

JUAN: Anna Marie isn't my girl, Georgia. She's my wife now.

GEORGIA: Well, she doesn't suit you.

JUAN: You're wrong. She suits me fine. She doesn't suit you. Come on now, Georgia. I'll start down real slow and you start down after me. *(Pause; she doesn't move.)* Are you going to start down after me, Georgia?

GEORGIA: I can't. Not until you start down first.

(JUAN starts slowly backing down the ladder. He stops after two or three rungs and looks back up at her. She smiles, and finally pivots her body onto the ladder, and they descend, JUAN almost wrapped around her as they back down.)

JUAN: Where are your house-shoes?

GEORGIA: Horseshoes?

(They reach the ground.)

JUAN: Come on inside.

GEORGIA: Look, Juan. *(She points.)* The jimson weed's come back. Stronger than ever.

JUAN: That's Johnson grass.

GEORGIA: No. Over there.

JUAN: That's sagebrush.

GEORGIA: *(She laughs.)* Where did you study botany?

JUAN: *(He takes her arm, to help her inside.)* Let's go. I've still got a million things to get done today.

GEORGIA: *(As they cross the threshold, she pulls away from him.)* What's that? Ssshh. I think we roused a rattler.

(He starts to stoop and look under the doorstep, then straightens and takes her arm again.)

JUAN: We haven't had a rattler in this yard in five years.

GEORGIA: Liar. You just want to make me feel safe, don't you?

(They go into the house.)

JUAN: Yes, Georgia. Yes, that's all I want. And for you to put on your goddamned house-shoes.

Scene Two:
Night at Home

(The light outside Georgia's house changes from densely colored late afternoon to paler early evening, then to full moonlight.

GEORGIA lights an oil lamp, somewhere inside her dark house, where we can't see her. Then the light of the lamp advances, and GEORGIA comes with it into the room with the large window, wearing only her nightgown, no slippers. She looks out the window, then moves to the radio/hi-fi console and starts a record: the Bach D Minor Sarabande performed by Casals.

Taking the oil lamp with her, she moves out onto her patio. She holds the lamp up high, and moves to shine it on some straggly plants in a corner by the fence. She smiles, a little nervously, and nods knowingly. She sets the lamp down on the packed earth and immediately begins to pull up these plants—Johnson grass, sagebrush—by the handful, the armful. They don't pull free of the earth as easily as the Jimson weed used to. She pants, struggles. Eventually she has a meager armful of the tattered stalks and leaves. She picks up the lamp with her other hand and moves across the patio slowly, singing the Duke Ellington tune.)

The Faraway Nearby 53

GEORGIA:
"Thought I'd visit the club ...
Got as far as the door ...
They have asked me about you ..."

(The last note breaks hoarsely. She stops still, puts the lamp down on the ground, then crouches in its glow, and inspects the uprooted plants. She drops all of them but one stalk of the Johnson grass. She rubs this frantically between the palms of her hands, then drops it, and smells first one palm, then the other; tastes first one palm with her tongue, then the other. She begins to cry, not very loud, and there are not many tears, though the sobs shake her violently from the inside.

After a while, morning light begins to shape the sky. GEORGIA has finished crying. She wipes her face with the hem of her long nightgown, then wipes her hands with it vigorously. She stands and goes into the house, and starts the Bach/Casals record again from the beginning, even if it has not yet concluded.

She picks up a black flat-brimmed Western hat from a table and puts it on, without tying it under her chin. She starts back out, but stops to pick up a huge cow skull from a bench beneath the large window. She comes back out onto the patio, into the morning light.)

Scene Three:
Morning at Home

(She carries the cow skull to the low stone step, where she was in the beginning, and sits beside it, draping her right arm proprietarily over it. She squirms for a moment, then settles herself reluctantly, as though for a photograph.)

GEORGIA: Take the damned thing. You're just wasting your time, and mine, trying to make it "life-like". It's not life, it's a mockery of life. And I want people to be able to see that, no matter how stupid they are.

(JUAN comes in from behind the house, dressed much as in Scene One of this Part, but with even more affluent mid-1980's touches. He carries an expensive leather briefcase. He sees GEORGIA and stops. She is aware of his presence, but doesn't turn to look.)

Who is that? Maria? I'll be in in a minute. They have almost finished immortalizing me.

(JUAN turns and goes into the house, disappears for a moment, then reappears with Georgia's slippers. He stops by the radio/ hi-fi console and lifts the needle off the Bach/Casals record. Then he comes out to the patio, moves to GEORGIA, sets his briefcase down, and squats to put the slippers on her feet.)

Juanito. I'm having another picture taken.

JUAN: No, you're not.

GEORGIA: *(She tries to wriggle out of the slippers.)* I hate those things.

JUAN: No, you don't.

GEORGIA: Oh. Did you buy them for me?

JUAN: Yes. Last Christmas.

(She looks at the slippers, as though for the first time.)

GEORGIA: They're nice.

JUAN: Yes, they are. I wish Christina would make you wear them. Where is Christina?

GEORGIA: Who? You didn't buy these house-shoes for your girlfriend and then give them to me because she didn't like them?

JUAN: Anna Marie is my wife, Georgia. *(He dusts off the step and sits beside her.)* She doesn't like any kind of house-shoe.

GEORGIA: Oh, I do. These are my favorites.

JUAN: I know.

(He takes the briefcase into his lap and opens it.)

GEORGIA: What's in there?

JUAN: A pile of work for us to do.

GEORGIA: To do together?

JUAN: To do together.

GEORGIA: It's not my will, is it? I hate looking at that thing.

JUAN: No, it's not your will.

GEORGIA: We're always looking at my will. *(Unconsciously, irritably, she kicks off her slippers.)* Weren't we looking at it yesterday?

JUAN: No.

GEORGIA: I hate that thing.

JUAN: I know, but you don't want to leave it all up to other people, do you? Stupid people?

GEORGIA: I don't want to leave it up to my sisters.

JUAN: No.

GEORGIA: I want to leave it up to you. Don't I?

JUAN: Not even to me. You can make your own decisions.

GEORGIA: I've always done that.

JUAN: Yes. *(He takes papers from the briefcase.)* The first thing is this agreement for the new book.

GEORGIA: The new book we're making.

JUAN: To go with the new exhibit.

GEORGIA: To start in New York.

JUAN: To start in Chicago.

GEORGIA: To start in Chicago, I mean. I decided it should start in Chicago.

JUAN: And they finally agreed to give us full control of the book too.

GEORGIA: We insisted on that.

JUAN: You have to sign the last three pages.

(He puts papers in her lap, and reaches into his briefcase for a pen.)

GEORGIA: People still want to see my work. All of you thought I'd run out of steam and people would forget about me. But the joke's on you. They even want to see pictures of me. A man was here this morning with his big goddamned camera and spotlights and a girl with her hair up in a bun asking me questions.

(He opens the document for her to sign.)

JUAN: The last three pages.

(He hands her the pen.)

GEORGIA: What is this?

JUAN: You need to sign the last three pages.

GEORGIA: *(She turns sharply and stares off.)* Ssshh!

JUAN: Georgia, they want this signed yesterday—

GEORGIA: Ssshh! *(She stands, letting the papers slide onto the earth of the patio.)* God, I haven't heard you for months now! *(She moves to one side of the patio, peers into the distance.)* Not for a

year, not since last Easter. *(She sings, joining in lustily with the voices in her mind.)* "O Jésus, por mis delitos—"

JUAN: The Penitentes?

(She gestures in his direction, without looking away from what she sees on the distant hillside.)

GEORGIA: Juanito! Go and start Sebastian Bach. I left him on the turntable.

JUAN: *(He doesn't move.)* All right, Georgia. I'm going.

GEORGIA: I have to answer them back, prayer for prayer. We always trade musics!

JUAN: *(He has not moved.)* I put it on, Georgia, Bach and Casals. Is it loud enough?

GEORGIA: *(She listens for a moment, without turning to look.)* Yes. It's good and loud. I know they must hear that, but they never look this way. They're not allowed to.—Strike hard! Make the blood listen!—You hear them, Juan?

JUAN: I hear them, Georgia.

GEORGIA: *(Her face changes; she turns and looks at him, not angry but serious.)* You're a goddamned liar. The Penitentes don't come anywhere near you anymore. Why do you lie to me?

JUAN: Because I don't know what else to do. What else can I do?

GEORGIA: I don't know.

(She looks off again, in the direction of the Penitentes.)

JUAN: Are you taking both your prescriptions? I think you still need both of them. *(He puts the papers and pen away in his briefcase.)* I think you have to move in to Santa Fe soon. With me and Anna Marie.

GEORGIA: Santa Fe? What's in Santa Fe? A lot of stupid people.

JUAN: I'm in Santa Fe now, most of the time. And my family. You could stay with us. We'd get somebody to look after you full-time.

GEORGIA: Christina looks after me full-time. Where's Christina?

JUAN: I don't know. It would be a hell of a lot easier to find somebody, somebody dependable, in Santa Fe.

GEORGIA: I detest Santa Fe. That's white man's New Mexico.

JUAN: You mean it's clean and safe and convenient.

GEORGIA: Exactly. I chose this dirt and danger and hardness out here. I chose it. I'd never choose Santa Fe.

JUAN: I'm not sure it's a question of letting you choose anymore. I think maybe it's a question of choosing for you now. Choosing what's safe. The way things are now.

GEORGIA: "Choosing what's safe." Remember, Juan? You stepped into the wedge of light that penetrated my shadow and you said, "I can help you, if you let me. With this and that."

JUAN: Yes.

GEORGIA: I never thought this and that would turn out to be Santa Fe. Choosing what's safe for me. What's safe for me will be the end of me. A mountain and desert animal can't live where it's safe. There's not room enough for her voice. Tammy Wynette, the giant winged lizard.

JUAN: You'll be fine, Georgia, you'll be just fine.

GEORGIA: In Santa Fe? No. I'm going on out to The Faraway for a while now, Juan. *(She turns and moves swiftly across the patio, into her house.)* I'm going to see if I can still find The Black Place.

JUAN: *(He does not move, but raises his voice.)* I'll find Christina and we'll see about some lunch for you. Then I'll help you start packing up your things.

(She looks around inside, finds a large pad of sketch paper and a large charcoal pencil.)

GEORGIA: I'll crawl up into The Black Place, if I have to. I know it's full of snakes nowadays, but I've never backed down from any kind of snake.

JUAN: We'll just take what you need for the first week or so, and have somebody send the rest of it on the bus.

(She comes back out onto the patio, with pad and pencil.)

GEORGIA: And the dogs have been driving me crazy for the past two weeks. They need some breathing space too. *(She calls into the house.)* Jingo …?

JUAN: Jingo's dead, Georgia. And Bo's living with me in Santa Fe. Poor old thing … He …

GEORGIA: *(She calls into the house.)* Bo?—You boys want to run wild in The Faraway once more before the hard frost? Want to get yourselves a snake or two? Come on!

(She moves far out onto the patio, to the edge of the light. JUAN watches, but does not stand or try to stop her. She obviously feels and hears and sees her two large chow dogs circling her, sniffing at her feet and legs. She laughs.) Well, go on then! Make a run for it! What's stopping you? *(She picks up a smooth stone or a piece of dry brush and throws it far out.)* Go! Run! Get away from it all! *(She laughs, as she watches the dogs race away from her.)* Jingo! Don't you take him too far! You have to show him. He's young, and so he's stupid! *(She laughs.)*

(Now, as she continues speaking, the setting behind her changes, or partially changes, to the desolate wildness and hard beauty of The Black Place. Maybe only the lights change this time. Maybe only the high stained wall of the ancient waterfall, which is dry again, appears amid the adobe and packed dirt surfaces of Georgia's home. Maybe the single twisted dead juniper suddenly appears in what is otherwise her patio.

JUAN doesn't move, but continues to watch her; except, somehow, he is now in The Black Place with her; or, at least, he knows that she has moved into The Black Place, and that he is observing her there.)

Scene Four:
Noon in The Black Place

(GEORGIA has moved here in spirit, but the setting is an odd blend of home and wilderness.)

GEORGIA: It's not just the colors that make this what I have always called The Black Place. It's the smell of these colors. It's the texture of the smell of these colors. It's the taste of the texture of the smell of these colors. I remember some young man, some boy, said to me once: "You're a strange one, O'Keeffe. Even though it's all white, glowing white crowded up into the foreground, the first word I think of, when I look at it, is 'darkness'." Yes. That is The Black Place. You have to pass the test again and again. You have to get to know The Black Place so well that you know even the whiteness and the stillness that are in it. At the end.

(She sits, holding the large pad of sketch paper in her lap. She prepares to sketch with the charcoal pencil, but doesn't. JUAN watches her; he doesn't move.)

I am moved in to Santa Fe. I look out the window of the car, and I see New Mexico slipping away, running in the opposite direction, my New Mexico, the red one, the Red. And I say, to someone who is driving the car, "I don't want to go, I don't want to leave. I haven't gotten it right yet. You know and I know that I will never get back to The Faraway, to The Black Place again." But he—or she—just smiles. "God, oh God. It doesn't make sense that I should still be struggling. Thrashing around, empty." Because I am here. No matter where they take me. And the old eye, the huge and young and beautiful old eye is still working somehow. It smells and tastes and hears and penetrates the shape, the simple terminal light-giving life-giving life-changing beautiful hard shape of The Black Place at last. I see it with my new insides. And that shape goes like this.

(She raises the pad of paper, takes up the charcoal pencil, and draws a strong clean line.)